ACC ART BOOKS

SPACE
POSTERS & PAINTINGS

ACC ART BOOKS

Contents

Introduction

Artwork associated with NASA has long been instrumental in conveying the gripping life-and-death challenges of space exploration. From the 1960s to the present day, several artists have captured NASA's work, each in their own dynamic style. The artworks in this book span a broad spectrum from terror to hope, daredevil missions to careful research, visualisation to pure speculation. Some were commissioned by NASA. Some were created independently. All speak to the wonders achieved by the storied space administration.

Among the most prestigious pieces are the works of NASA's pre-eminent artist, Robert McCall, whose daughter Catherine has contributed the finest collection of his NASA-themed paintings, along with a personal tribute to the man himself. This Robert McCall collection alone captures the essence, adventure and spirit of NASA's remarkable endeavours.

Also included in these pages are many jaw-dropping artworks depicting NASA's early Gemini and Apollo missions, humanity's first steps on the Moon, images of the Space Shuttle and more. One chapter features a collection of 1950s-monster-movie-style posters, illustrating the dangers of outer space, including 'Dark Energy', 'Zombie Worlds' and the 'Galactic Graveyard'! After witnessing the menace of these sci-fi posters, you'll want to hide under your bedsheets until the golden rays of dawn pierce the night.

Elsewhere, you're invited to look forward to the wonders of commercial space travel and challenged to play your part in the colonisation of Mars.

In a world of constant video saturation, these masterpieces, illustrations and infographics allow us a moment to celebrate NASA's work and rejoice in the immense power of a single image to convey a primal sense of wonderment.

NASA has always championed efforts to communicate the message of peaceful space exploration to all language groups, often using visual arts to encourage the world to dream. Art is indeed a universal medium that reflects our ambitions and fears. Thus, within this relatively simple book, each page represents the eternal longing of all humankind to reach beyond the stars.

The Visionary Paintings of Robert McCall

A Tribute

My father, the artist Robert McCall, was passionate about everything he did and was constantly sketching or photographing the world as he saw it. He relished life and all of its abundance. I remember spending hours looking through the microscope or the telescope with him. On hot summer afternoons, he would take water samples from the brook and we would gaze at the 'teeming life' from the stagnant water. His fascination was contagious. Then, late at night, he would show us the planets through the telescope. He lectured us about the microcosm and the macrocosm. Later, I would recognise these themes in his paintings.

He was a perfectionist when it came to his artwork, which evolved slowly from illustration to fine art. His style was precise enough to express the science of the space program at the same time as being loaded with hopeful, positive subject matter. Space is desolate, lonely and cold, but Daddy kept showing us the playfulness of mankind, discovering bright lights and scrumptious colours. The beauty he depicted, no one had actually seen at that time, so he had the freedom to interpret space with a massive, detailed and engaging warmth that encouraged a future in space exploration.

As he got older, his art became even more fantastic. He continued to accept commissions that needed to be accurate and scientific, while he took artistic licence to depict fabulously futuristic landscapes, space craft and nebulae. The film industry sought him out and he was an art director on several films. He became the darling of Scottsdale (AZ) society. He donated the stained glass for an octagonal chapel at his church; he gave art to the hospital; and he was honoured by the Arizona Historical Society as an Arizona Historymaker. He sold directly to wealthy families and relished the attention and tremendous success his art was bringing.

My father was a bright spark of optimism. His art was his livelihood and his life. He was compassionate and kind. His personal goal was to inspire future generations to keep exploring outer space and discovering, as he would say, 'the wonders of the universe'.

Catherine McCall

Commissioned directly by NASA, Robert McCall chronicled the US space program for more than thirty-five years. His breathless vistas and detailed aeronautic architecture offer the most extraordinary glimpses of humanity's future in the cosmos.

MISSION TO MARS

Are you brave enough to answer the call **to explore** our notorious neighbour?

WE NEED YOU

These adverts from 2016 invite us to consider the roles we could play in future missions to Mars. According to NASA's campaign info, 'having the skills and desire **to dare mighty things** is all you need'.

The Exoplanet Travel Bureau

Ever find yourself wishing for a one-way ticket to the Moon?

How about a grand tour of the solar system?

55 Cancri e

lava life

Skies sparkle above a never-ending *ocean of lava*

TITAN

RIDE THE TIDES THROUGH THE THROAT OF KRAKEN

VENUS

SEE YOU AT THE CLOUD 9 OBSERVATORY

VOTED *Best* PLACE IN THE SOLAR SYSTEM TO WATCH THE MERCURY TRANSIT

VISIT THE
HISTORIC SITES

MARS

MULTIPLE TOURS AVAILABLE

ROBOTIC PIONEERS / ARTS & CULTURE / ARCHITECTURE & AGRICULTURE

VISIT BEAUTIFUL SOUTHERN

ENCELADUS

MORE THAN 100 BREATHTAKING GEYSERS! THE HOME OF "COLD FAITHFUL" BOOKING TOURS NOW

PLANET HOP FROM

TRAPPIST-1e

VOTED BEST "HAB ZONE" VACATION WITHIN 12 PARSECS OF EARTH

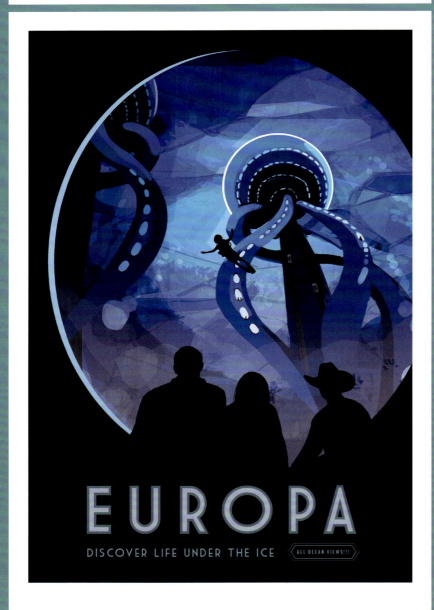

EUROPA

DISCOVER LIFE UNDER THE ICE · ALL OCEAN VIEWS!!!

Kepler-186f

WHERE THE GRASS IS ALWAYS **REDDER** ON THE OTHER SIDE

A ONCE IN A LIFETIME GETAWAY

THE GRAND TOUR

JUPITER / SATURN / URANUS / NEPTUNE
EXPERIENCE THE CHARM OF GRAVITY ASSISTS

 EVERY 175 YEARS

NOW BOARDING

FEAR THE GALAXY OF HORRORS

WITNESS THE TRUE TERROR OF DEEP SPACE ACCORDING TO REAL NASA SCIENCE!

THESE MONSTER-MOVIE POSTERS FROM HALLOWE'EN 2020 REVEAL THE NIGHTMARES LURKING BEYOND THE FINAL FRONTIER.

MACS 2129-1 STARS IN:

GALACTIC GRAVEYARD

BASED ON REAL SCIENCE

BEWARE: IT'S OLD, RED AND DEAD!

THIS **CHILLINGLY HAUNTED** GALAXY **MYSTERIOUSLY** STOPPED MAKING STARS ONLY A **FEW BILLION YEARS** AFTER THE **BIG BANG!**
IT BECAME A **COSMIC CEMETERY**, ILLUMINATED BY THE **RED GLOW** OF **DECAYING STARS.**
DARE TO ENTER, AND YOU MIGHT ENCOUNTER THE **FRIGHTENING CORPSES OF EXOPLANETS** OR THE FINAL **DEATH THROES** OF ONCE-MIGHTY STARS.
A **HUBBLE SPACE TELESCOPE** OBSERVATION

GALAXY
OF
HORRORS

exoplanets.nasa.gov

A *COSMOLOGICAL* FEATURE

THIS BONE CHILLING FORCE
WILL LEAVE YOU SHIVERING ALONE
IN TERROR

DARK ENERGY

AN UNSEEN POWER IS PROWLING THROUGH THE COSMOS, DRIVING THE UNIVERSE TO EXPAND AT A QUICKENING RATE. THE RELENTLESS PRESSURE, CALLED DARK ENERGY, IS NOTHING LIKE DARK MATTER, THAT MYSTERIOUS MATERIAL ONLY REVEALED BY ITS GRAVITATIONAL PULL. DARK ENERGY OFFERS A BIGGER FRIGHT: PUSHING GALAXIES FARTHER APART OVER TRILLIONS OF YEARS, LEAVING THEM TO AN INESCAPABLE FREEZING DEATH IN THE PITCH BLACK EXPANSE OF OUTER SPACE.

FEATURING NASA'S WEBB SPACE TELESCOPE
& NANCY GRACE ROMAN SPACE TELESCOPE

GALAXY OF HORRORS
exoplanets.nasa.gov

GUEST STARRING
ESA'S EUCLID MISSION

www.nasa.gov

EYES IN THE SKIES

Some say that whenever we look up to the stars, billions of other lifeforms are blinking back at us. NASA's search for the great wonders of the cosmos continues with the help of these monumental telescopes.

SPITZER
SPACE TELESCOPE

HOUSTON to APOLLO

n 1969, humankind landed on the Moon for the first time, all thanks to NASA's successful Apollo 11 spaceflight. The legendary Apollo Program was announced in the early '60s and continued for around a decade. Our world has never been the same since.

APOLLO 11 — Descent To Lunar Surface

Transfer To LM

Separation Of LM From CSM

Landing On Moon

First Step On Moon

APOLLO 11 — Lunar Surface Activities

Experiment Placements

TV Camera

Alignment Of Passive Seismometer

Bulk Sample Collection

LUNAR ROVING VEHICLE Initial Deployment Sequence

MSFC-71-IND 1200-126-A-1 of 2

LUNAR ROVING VEHICLE Final Deployment Sequence

MSFC-71-IND 1200-126-A-2 of 2

APOLLO 11 — Lunar Ascent And Rendezvous

Return To Spacecraft

Ascent Stage Launch

Rendezvous And Docking

LM Jettison

APOLLO 11 — Transearth Injection And Recovery

Transearth Injection

CM/SM Separation

Reentry

Splashdown

Recovery

ROCKET SCIENCE

Get *ready for*

blast-off...

With technical precision
the like of which has never
previously been achieved,
NASA's vehicles have
repeatedly surpassed
the boundaries of human
existence.

MSFC·70·PD·4000·4B

NASA-S-65-893

USA

SOLAR SURFING

NASA INNOVATIVE ADVANCED CONCEPTS

National Aeronautics and
Space Administration

NASA

Captions to Illustrations

p.3 Painted by Alexei A. Leonov, commander of the Soviet ASTP, this represents the joining together of Soviet and American spacecrafts above the Earth. Made in the early 1970s, following an agreement between the rival superpowers, Leonov intended this piece to symbolise a dawning era of international co-operation in space.

pp.4-5 An artist's interpretation of the Apollo 15 Moon landing in 1971, with two members of the crew freewheeling in their Lunar Roving Vehicle. Artwork by Robert Watts for Tenedyne Ryan.

p.7 Concept art from North American Rockwell (later known as Rockwell International), a manufacturing company once responsible for building and assisting with many of NASA's vehicles. The Apollo 10 Lunar Module descends towards the landing area in the Sea of Tranquility. Artwork by North American Rockwell.

THE VISIONARY PAINTINGS OF ROBERT MCCALL

pp.8-9 A horizontal section study for *Cosmic View*, the six-storey space mural in the Smithsonian Institution's National Air and Space Museum in Washington DC. This version is acrylic on canvas, painted in 1975.

p.10 Painted in 1989, this shows the launch of the Hubble Space Telescope, which would take place the following year.

p.11 A vertical section study for *Cosmic View*, 1975.

pp.12-13 *First Men on the Moon*. Painted in 1970, this swirling oil on canvas shows Neil Armstrong and Edwin E. (Buzz) Aldrin with the sunlit Earth among the stars above. The command module, piloted by Michael Collins, twinkles like a shooting star as it passes in orbit.

p.14 Concept for a Mars transfer vehicle.

p.15 (top) This concept painting shows a telescope in a hypothetical lunar observatory, sheltered from the Sun to protect its lens.
(centre) Astronauts wave farewell to a craft as it blasts off from a base on Mars.
(bottom) Another of Robert McCall's classic concept paintings. In an effort to produce life-sustaining materials on the Moon, this 'lunar combine' is tilling the fine dust on the surface, while the solar farm beams energy back to Earth in the form of microwaves.

pp.16-17 *Space Sail of the Future*, 1960. A regatta of sunlight-powered sailboats high above the Earth.

p.18 (top) A detail of *Astronaut Edward H. White II First American to Walk in Space*. Created in 1970, five years after the fact, this was inspired by the sense of exuberance and freedom that White conveyed when describing the space walk to McCall. As McCall explained, 'he was so thrilled with that freedom that it was difficult for Mission Control to talk him back into the capsule'. White was killed in the Apollo 1 launchpad fire in 1967.
(bottom) McCall witnessed first-hand the serene landing of the Columbia in the Mojave Desert.

p.19 McCall was also present at the Columbia's launch, as NASA returned to space, having been grounded for five years.

pp.20-21 Detail of a mural named *Opening the Space Frontier – The Next Giant Step*, painted in 1979 for the Johnson Space Center in Houston.

MISSION TO MARS

p.23 (and front cover) If we're to reach the red planet, NASA needs adventurers and daredevils, as well as engineers, technicians, farmers, statisticians, physicists, astronomers, teachers, construction specialists, chefs, surveyors and more. Ultimately, that means NASA needs YOU!

p.24 A brave soul hikes the Martian valleys.

p.25 (top left) Ever considered teaching abroad? This poster recommends Mars as a dream destination.
(top centre) Mining for resources on Phobos, the larger of Mars's two moons.
(top right) Explorers will need to assess the Martian terrain under the watchful gaze of Phobos and Deimos.
(bottom left) Hungry explorers need feeding. According to NASA, it's entirely possible to grow fruit and veg in space.
(bottom centre) Can you fix a bicycle? Maybe you can also assemble a parabolic omnidirectional satellite antenna on the surface of Mars.
(bottom right) It's impossible to predict all the challenges astronauts might face on another planet. Anyone daring to venture across the solar system will need to think for themselves.

THE EXOPLANET TRAVEL BUREAU

p.26 (left) Considered by some to be the first exoplanet (planet beyond our solar system) ever discovered, 51 Pegasi b is a giant, dancing nose-to-nose with its star in an orbit that lasts just over four Earth days.

(right) HD 40307 g is only twice the size of Earth in volume, but eight times more massive, meaning it likely has an intense gravitational pull.

p.27 The floor really is lava on 55 Cancri e, where molten seas are reflected in the silicate skies above, creating dazzling 'curtains' of particles, glowing hot as it closely orbits a sun named Copernicus (after the famous Polish polymath).

p.28 Kepler-16 b orbits a 'binary star' – two stars bound to the same gravitational centre. NASA's website describes it as 'the first Tatooine-like planet found in our galaxy', in reference to Luke Skywalker's home world in the *Star Wars* films.

p.29 What better place for a nightclub than a planet where it's always night? PSO J318.5-22 is a strong contender, clothed in perpetual darkness as it wanders the abyss without a solar system to call its own.

p.30 Saturn's largest moon, Titan, is thought to bear the scars of liquid methane and ethane flowing over its surface. NASA has also observed evidence of liquid water. The Cassini orbiter has been sent to investigate.

p.31 According to NASA, Jupiter's clouds host the most wondrous auroras, dancing around each pole in glowing rings bigger than our entire planet.

p.32 Captain James Cook once sailed to the South Pacific to watch Venus and Mercury cross the face of the Sun. This poster recommends travelling even further for front-row seats.

p.33 Is it possible that future generations will visit Mars to see historical artefacts, such as the X-ray spectrometer from the first rover and the husks of the first Mars-colony houses?

p.34 (top left) The incredible icy jets of Saturn's Enceladus suggest the existence of a liquid ocean and the potential for life to exist beneath the frozen surface of this snowy moon.
(top right) According to NASA, the TRAPPIST-1 system is a cluster of seven rocky, Earth-sized planets, huddled around their dim, red star 'like a family around a campfire'. TRAPPIST-1e sits in the habitable zone and is perhaps the most likely to contain liquid water and life.
(bottom left) Enceladus isn't the only moon with the potential for life. Jupiter's Europa is believed to be covered in a saltwater ocean twice as voluminous as all the Earth's oceans combined.
(bottom right) Visit Kepler-186f, the first Earth-sized planet discovered in the 'habitable zone' around a distant star, albeit a star much redder and less potent than our own. The red star's photons could have an impact on the colour palette of the planet's flora.

p.35 Launched by NASA in 1977, Voyagers I and II used the gravity of each planet in turn to slingshot their way around the solar system. Perhaps, one day, passenger vehicles will be able to do the same.

FEAR THE GALAXY OF HORRORS

p.37 The planets caught within reach of a pulsar are destined for a slow demise, lingering in orbit as if hypnotised by the light of their undead star.

p.38 Beware the galactic graveyard discovered by the Hubble telescope. What malevolent forces caused this entire galaxy to die? Are those forces still at work? Could the same thing happen here?

p.39 Take your seats for a ghoulish vision of dark energy as it threatens to turn the universe into a silent tundra.

p.40 NASA says dark matter appears to attact all other matter, and that its existence was confirmed during the '70s by American astronomer Vera Rubin and her team of researchers. Otherwise, we know very little about this unseen substance, wending its way through the universe.

p.41 Broiled alive by its own sun, HD 80606 b's torment is unending.

p.42 (and back cover) When a pair of suns collapse into each other, there's no escaping the deathly afterglow.

p.43 Brace yourself for a slash landing on HD 189733 b, whose glass-needle winds can turn your body to coleslaw in an instant.

EYES IN THE SKIES

p.44 (left) Much like Captain Cook, the Kepler Space Telescope watched the skies for planetary transits. Launched in 2009 and retired in 2018, it helped us discover thousands of exoplanets by observing their shadows in the faces of distant stars.
(right) TESS, the Transiting Exoplanet Survey Satellite, replaced Kepler in the ongoing search for Earth-like worlds.

p.45 Sent into Earth orbit in 1990, Hubble completely changed the way we see the stars. Among its many achievements, this famous telescope has proven the existence of an exoplanet's atmosphere by sensing changes to the star's light passing through it.

p.46 (and back cover) In 2003, the Spitzer Space Telescope took off with the mission to become NASA's primary infrared observatory. It has since shown us supermassive black holes, faraway galaxies and a previously unseen ring around Saturn. This poster shows the telescope assisting with the discovery and further study of the TRAPPIST-1 system.

p.47 By picking up infrared light, NASA's powerful James Webb telescope can see through time itself, allowing researchers to glimpse the very first galaxies and detect water vapours in the skies of far-off planets.

HOUSTON TO APOLLO

p.48 A concept illustration for Apollo 8 (c.1968).

p.49 An artist's rendition of the Apollo-Soyuz linkup, an extraordinary feat of diplomacy and co-operation, not to mention aerospace engineering. Artwork by Paul Fjeld.

p.50 (top left) These sketches show Apollo 11's descent to the lunar surface and activities performed by Commander Neil Armstrong and lunar module pilot Edwin E. (Buzz) Aldrin while on the Moon.
(bottom left) Illustrations showing the deployment of the LRV. This lightweight vehicle allowed astronauts to cover much greater distances on the lunar surface.

pp.50-51 (right) Interpretation of an Apollo lunar landing module, roving unit and astronauts, by Grumman artist Craig Kavafes.

p.52 (top) Painted in 1971, this shows the Apollo 14 command and service module in lunar orbit, while the lunar module descends in the background.
(bottom) More sketches of the Apollo 11 mission, showing (left) the lunar module's ascent from the Moon and rendezvous with Michael Collins's command module; followed by the return to Earth (right).

p.53 The nervous first moments of ascent as Apollo 11's lunar module begins the journey home.

p.54 A concept painting of the Apollo 9 mission. This was the first time a lunar module had been crewed in space.

p.55 (top) Apollo 9 during an EVT (Extra Vehicular Transfer), whereby an astronaut exits one vehicle and enters another in space.
(bottom and back cover) A crewed Apollo command module re-enters Earth's atmosphere during the Apollo 7 mission.

pp.56-57 Robert McCall's interpretation of the Apollo-Soyuz linkup.

ROCKET SCIENCE

pp.58-59 (and back cover) An astronaut on Mars. Future Moon landings may be used to test the equipment needed for Mars missions.

p.60 (left) Saturn 1B. These thunderous launch rockets were commissioned for the Apollo missions and later propelled astronauts on their way to the Skylab space station.

p.60-61 (right) NASA's mighty Skylab was launched in 1973, becoming America's first space station, illustrated here by Robert McCall.

p.62-63 An artist's concept for the Apollo-Soyuz linkup, with cutaways showing the American astronauts and Russian cosmonauts at work in their respective vehicles - including one giant handshake for mankind. Artwork by Davis Meltzer.

p.63 (centre) Apollo 11's Saturn V rocket on the launchpad.
(right) A capsule from Project Mercury (c. 1958-63), NASA's first human spaceflight program. Credit: NASA.

pp.64-65 (background) Diagram of a space shuttle.

p.64 (top left) Early concept of a space shuttle being refuelled by a 'space tug' – smaller spacecraft typically intended for orbiting Earth with cargo, fuel, etc.
(top right) Artist's cutaway of a Gemini capsule.
(bottom left) An illustration of Spacelab 2, a research laboratory housed in the cargo bay of an orbiting shuttle.
(bottom right) Rockwell artwork of a shuttle launch.

p.65 Samples on their way home from a rudimentary Mars base.

p.66 A team of researchers at NASA's Kennedy Space Center have been developing a reflective shield for ships attempting to reach the transition zone' 500,000 miles from the surface of the Sun. This stylish rendering was created to help visualise the concept.

p.67 Gemini artwork, including blueprint-style diagrams and cutaways showing the astronauts in their capsules. Credit: NASA.

pp.68-69 A classic Rockwell artwork, showing two astronauts straddling the Apollo 15 command and service module during an EVA. Artwork by North American Rockwell.

p.72 The search for habitable planets in the vastness of space is a classic Goldilocks situation - too scorched, too gaseous, too engulfed in lethal radiation. Thankfully, our very own Earth is just right.

Acknowledgements

With much respect and admiration, I would like to thank the executives at the Jet Propulsion Laboratory (JPL) in Pasadena, the executives at NASA Headquarters in Washington DC, Catherine McCall for her gracious access to her father's amazing paintings, and all the other talented artists whose works are included within this book. These artists truly inspire hope, dreams and adventure.

Bill Schwartz

ISBN: 978 1 78884 278 5

Introduction by Bill Schwartz
Tribute by Catherine McCall

ACC writer/editor: Stewart Norvill
Designer: Steven Farrow
Reprographics: Corban Wilkin

Robert McCall paintings reproduced with kind permission of Catherine McCall. All other images courtesy of NASA.
Back cover background: Peter Jurik / Alamy Stock Photo

Printed in China
for ACC Art Books Ltd, 6 West 18th Street, 4B, New York, NY 10011

www.accartbooks.com

ACC ART BOOKS

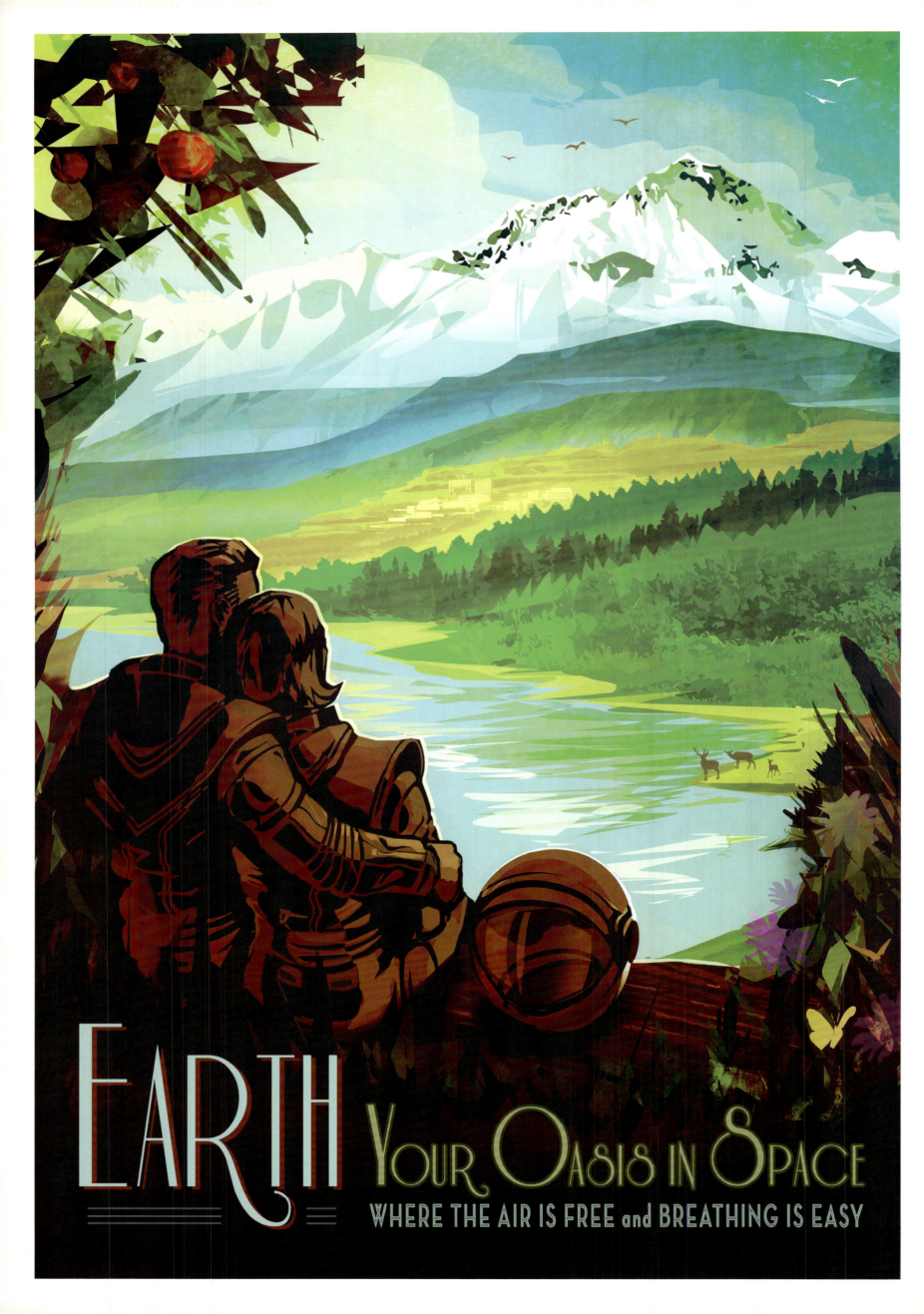